Playing

Chess

HEART

Playing *Chess* WITH THE HEART

Beatrice Wood AT 100

PHOTOGRAPHY BY MARLENE WALLACE
WITH QUOTATIONS BY BEATRICE WOOD

CHRONICLE BOOKS
SAN FRANCISCO

Photographs copyright © 1994 by Marlene Wallace.
Text copyright © 1994 by Beatrice Wood.

Printed in Singapore.

Library of Congress Cataloging-in-Publication Data
Wood, Beatrice
 Playing chess with the heart: Beatrice Wood at 100/
 photographs by Marlene Wallace.
 p. cm.
 ISBN 0-8118-0607-3
 I. Wood, Beatrice—Portraits. 2. Wood, Beatrice—Philosophy.
 I. Wallace, Marlene. II. Title.
 NK4210.W63A2 1994
 738'.092–dc20 93-25852
 CIP

Cover and book design: Gretchen Scoble and Sarah Bolles
Calligraphy: Georgia Deaver
Cover Illustration: Ward Schumaker
Distributed in Canada by Raincoast Books
8680 Cambie Street, Vancouver, B.C. V6P 6M9

10 9 8 7 6 5 4 3 2

Chronicle Books
85 Second Street
San Francisco, California 94105

Dedicated to my children,

Wynne, Ron, Max, and Chloe

One day in a ballet class at the Happy Valley School, I looked into the mirror and saw reflected there the most amazing sight I had ever seen—a woman in boots, clanking with American Indian jewelry, dancing at the back of the room.

I was fourteen and very serious about ballet. The woman was Beatrice Wood and very serious about enjoying life; "an artist," my grandmother explained, rolling her eyes. I was enchanted then and have been ever since (as has the rest of the world).

Over the years I have been privileged not only to photograph Beatrice Wood, the artist, but also to come to know Beatrice Wood, the person. It is, of course, impossible to separate one from the other. Her warmth and joy as a human being is carried into her work and transformed into gifts for us from her soul.

My photographs of Beatrice are my tribute to the many complexities of this wonderful talent and valuable friend. She is ever changing and ever the same. She is thoughtful, serious, insightful, and profound, as well as humorous, mischievous, feminine, and sensual. She is one of the great artists of our time and one of the greatest friends I have ever known.

Through the eye of my camera lens, I have tried to capture the numerous layers of her wondrous personality. Here, then, is my friend Beato.

MARLENE WALLACE
May 1993

Eighteen years ago, a tiny golden figure like a ray of sunlight burst into my exhibition room, carrying a camera bag almost as big as herself. Though her grace of movement and sparkling eyes arrested my attention, I was soon impressed that this laughing creature was a thoughtful woman, who had come out of the river of experience with understanding and compassion.

Not only did we quickly become friends, but I was soon full of admiration for her professionalism and the inventiveness of her mind. She has taken photographs of me at various stages of my work and has always been sensitive to my true femininity. She has the ability to portray me as the thirty-two-year-old that I choose to be, not the old woman others see.

BEATRICE WOOD
February 1993

Legs are provocative engineering, for the smallness of feet is made to maintain incredible weight.

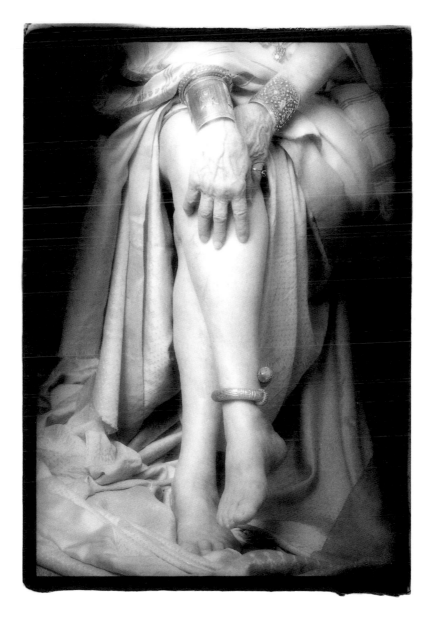

It seems to be a natural law that the strong protect the weak. That is why it is cruel to kill animals unable to defend themselves.

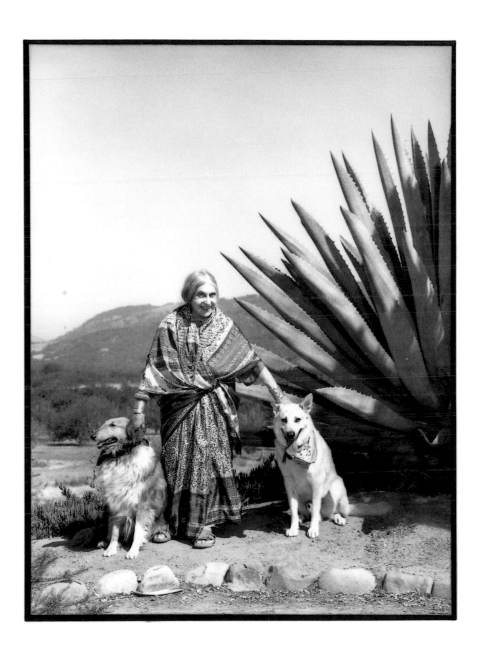
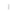

Freedom is tested when we lift the mind from our bodies and endeavor to keep it open.

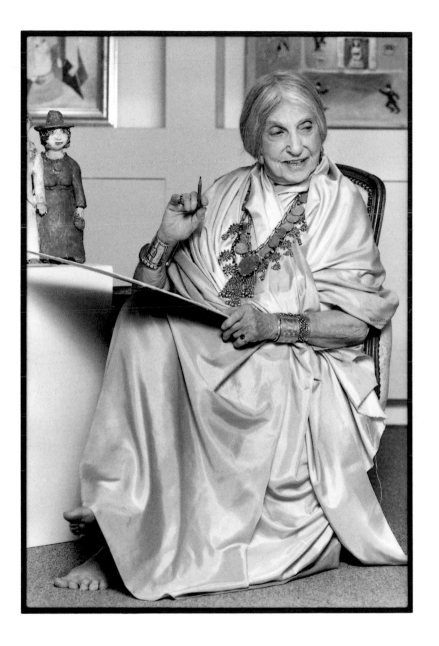

Infatuation is different from love.
Sometimes they go together, but alone,
infatuation is just sexual energy on
a spree.

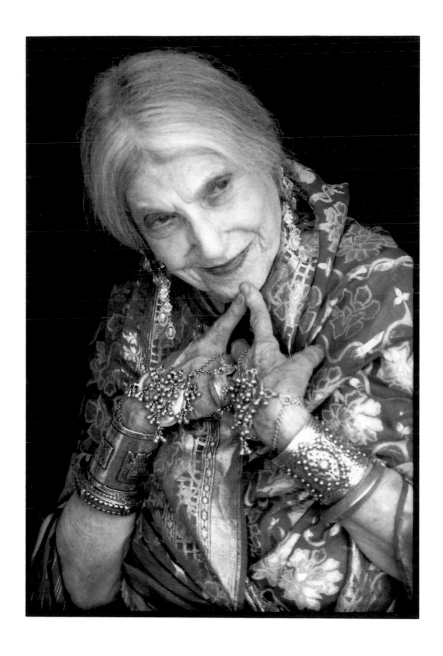

Everyone makes mistakes; we learn by them. If we were perfect, there would be no reason to live.

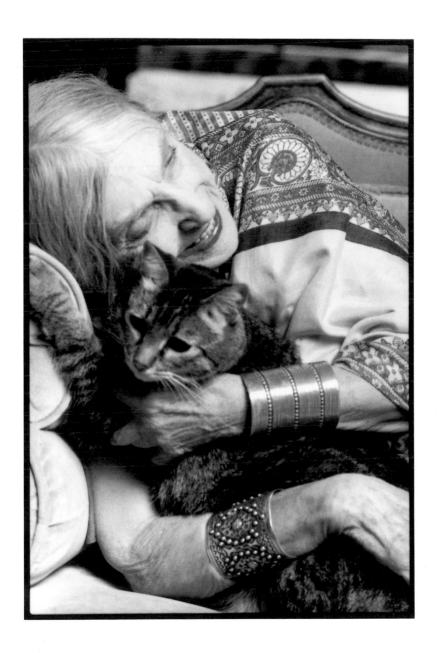

It is in silence that new thoughts come. If we divert the mind with too much distraction, it becomes scrambled like eggs.

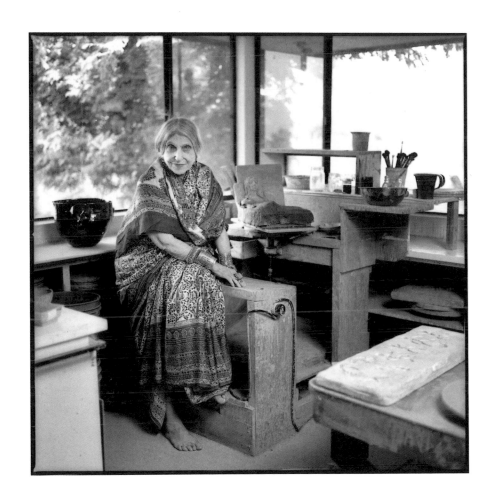

Around 80 percent of our technical genius is focused on destruction, on killing. Beings from space must be laughing at us.

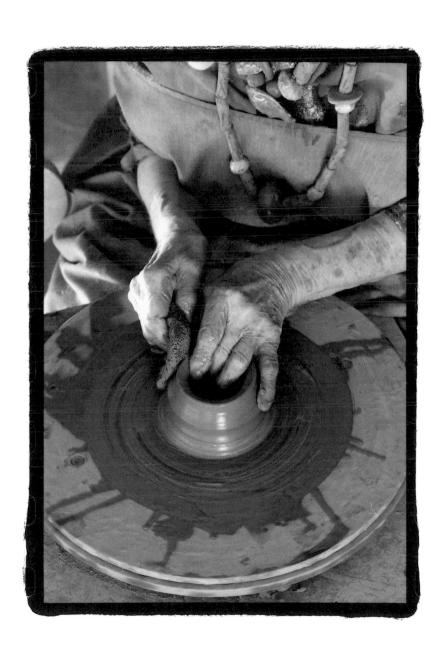
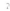

Anyone can make a hole in clay, but few can bring beauty and sensitivity to the hole. It is the true artists who lift the race in science, medicine, and creativity.

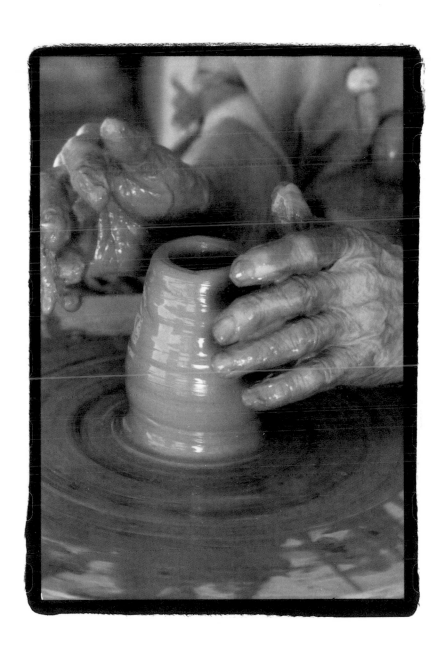

24 Pottery makes for self-discipline. If one errs, a bowl is out of line. It takes patience to follow the road of life which leads in the right direction.

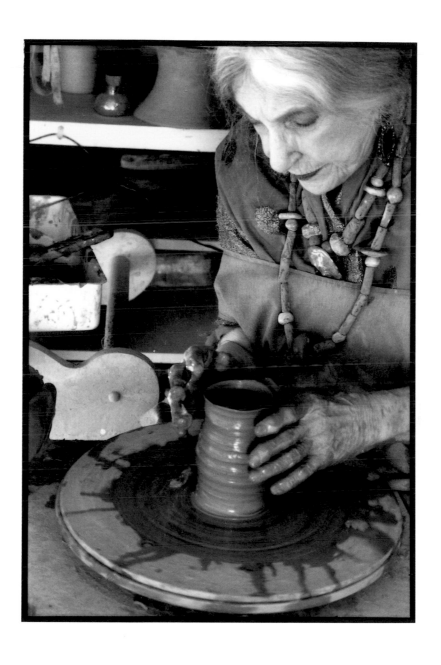

26 When we say "no" to our children, it creates opposition. Overly strict parents may push children into forbidden territory.

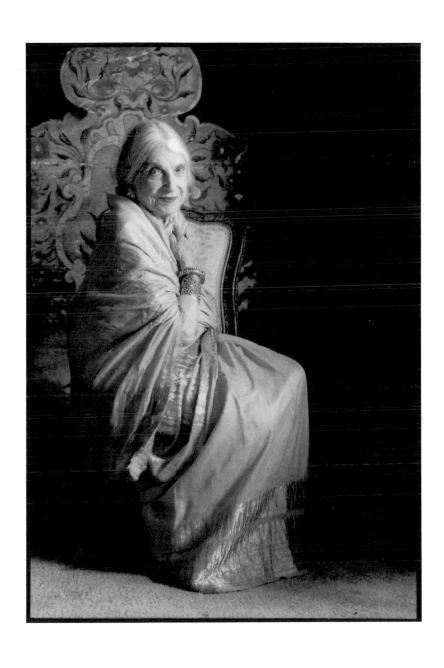

28 We learn from handicaps. They awaken energy which is needed to overcome them, and thus wisdom is born.

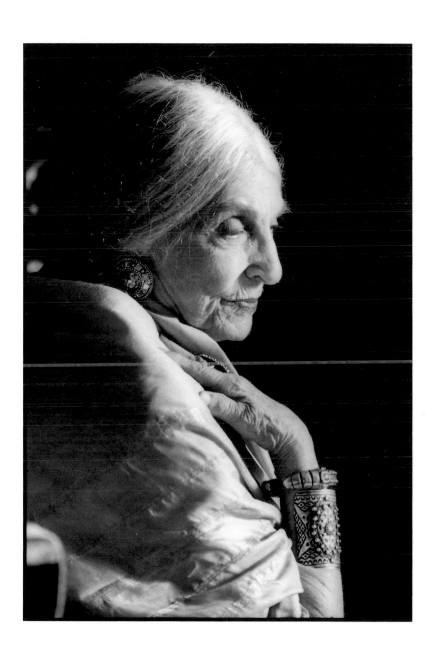

Between men and women, it is fun playing chess with the heart.

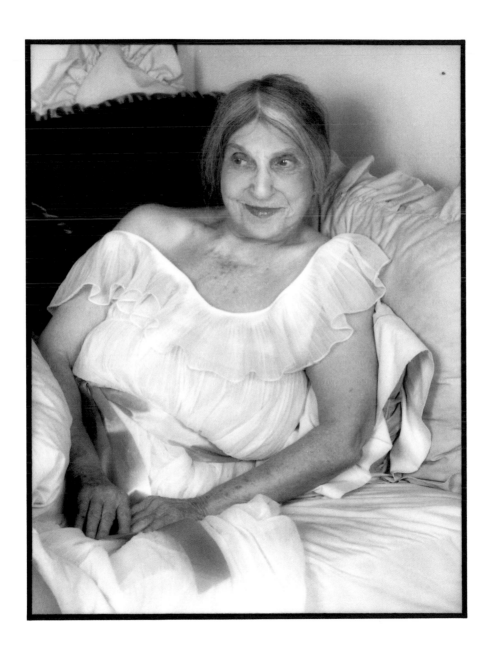

Some angels are known for the black tights they have worn.

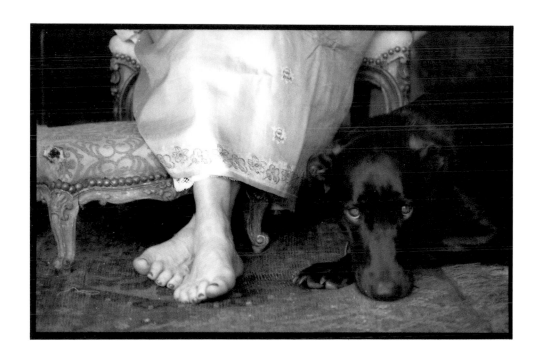

33

34 Little girls dream of knights on white horses carrying them away to eternal bliss. Too bad the dream cannot be held onto.

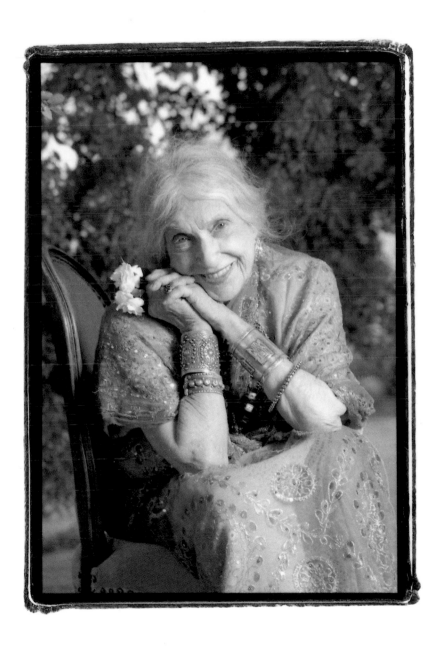

Let us face it, it is not a question of whether the law is right or wrong where abortion is concerned. Any woman desperate enough will go to an abortionist regardless of whether there is a law against it. To speak of saving a fetus is to ignore the dangers facing a woman having an illegal abortion — which could mean the loss of two lives.

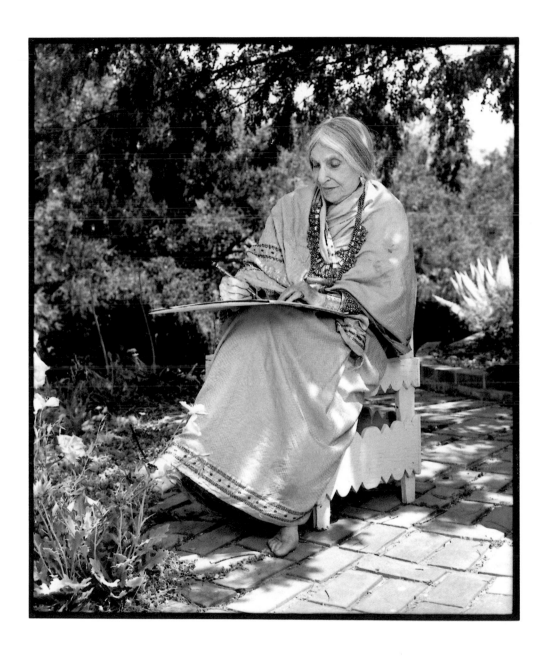

As eyes become sensitive, we begin to understand the extraordinary things man has accomplished in life.

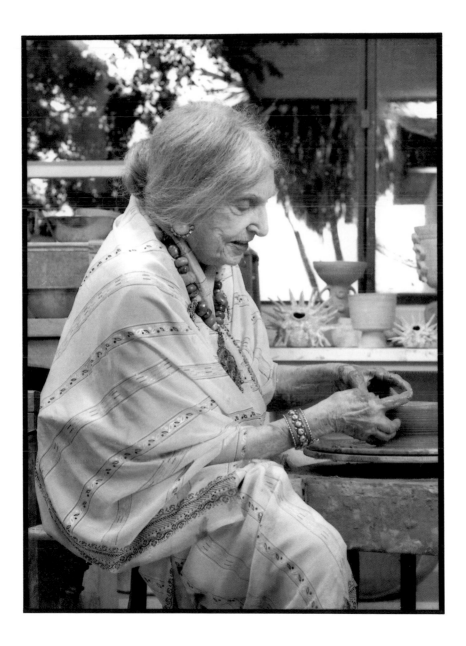

40 *Artists are people who have inspired civilization with beauty and invention.*

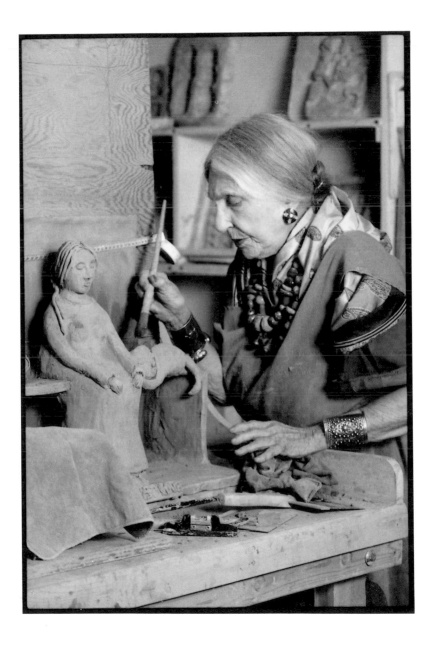

A chance remark can develop into a war.
The complexity of relationships is impossible
to unravel.

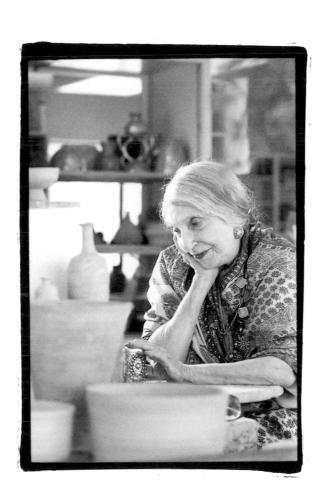

Two pet cats opened the door to love for me.
When faced with being able to save only one
in an emergency, I realized love cannot
be measured and is limitless. Solomon
proposed cutting a child in two. Love is free
of possession.

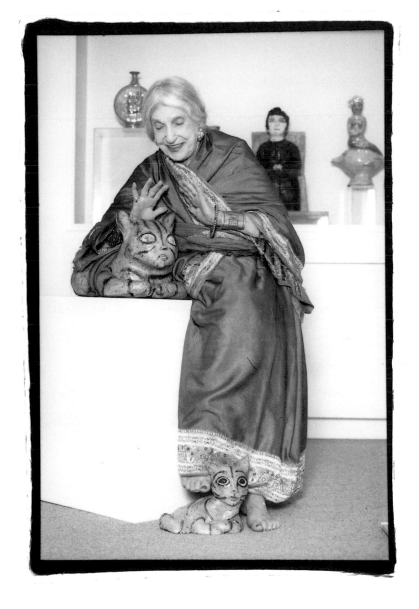

15

Somewhere in the beginning, something went wrong. Man became capable of killing his own kind, building endless walls of separation.

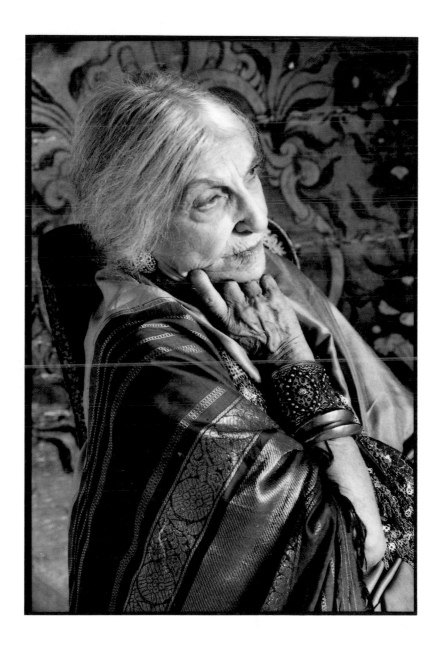

48 Our actions often reflect our emotional and economic situation. Therefore, we should not judge, but understand and help.

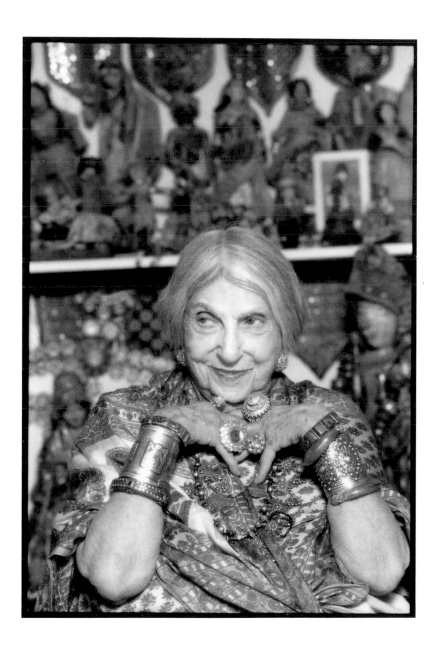

50 Because we are becoming one world, we should tear down the walls of color and the artificial boundaries between nations.

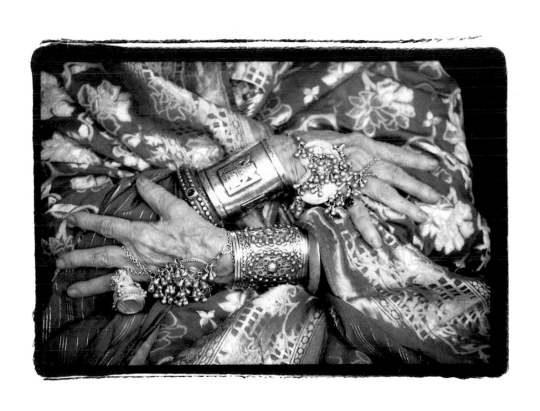

It is curious, but if one smiles, darkness fades.

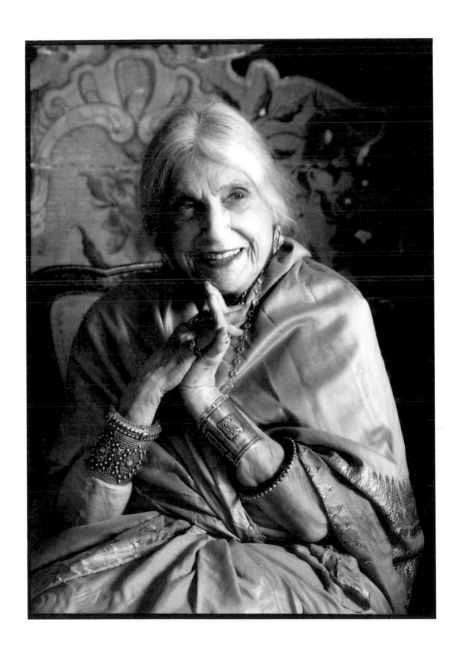

Celibacy is exhausting.

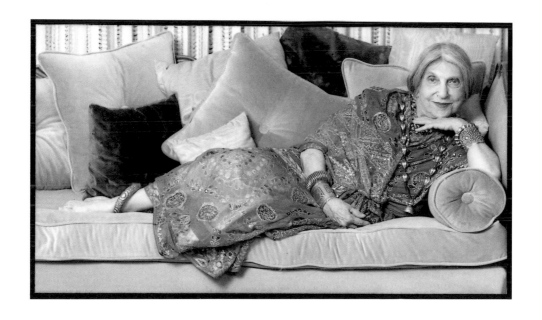

As we face global dilemmas, we must understand that no one should take destruction of life into his or her own hands.

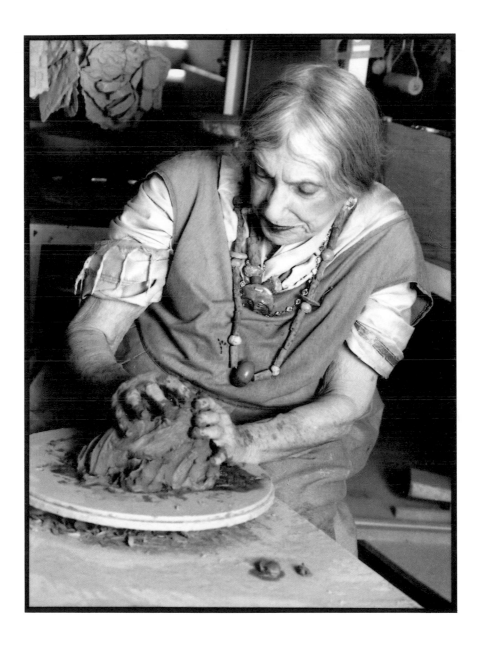

Ironically, the things that happen easily often turn out to have the best rewards.

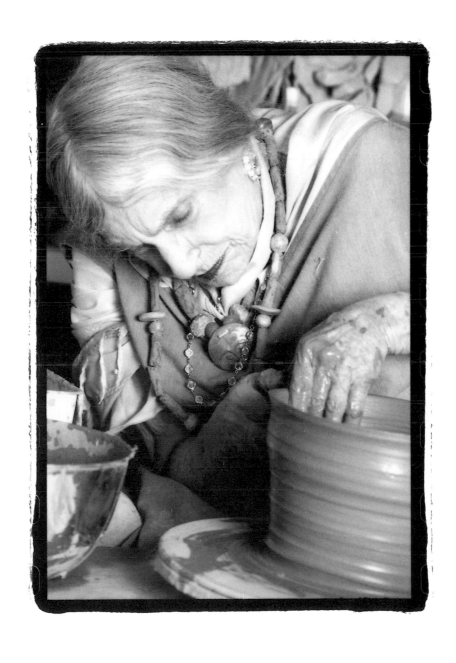

60 We are here on account of sex, though we
do not understand its force. There is
glory when the sexual force is used
creatively, when it is open to the magic
of the universe.

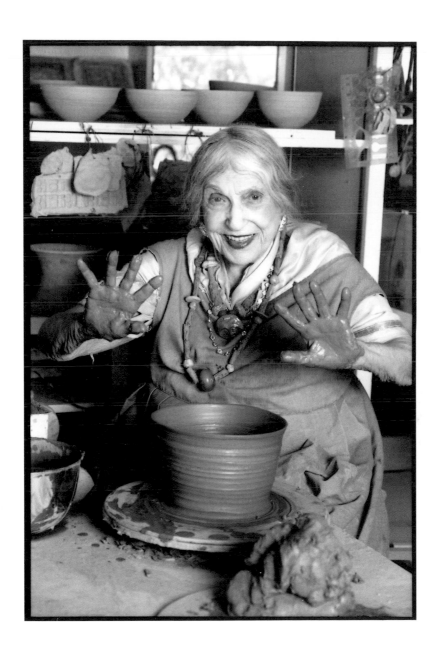

Curiously, man, with his unlimited intelligence, may still overlook the basics, such as providing our children with a good education.

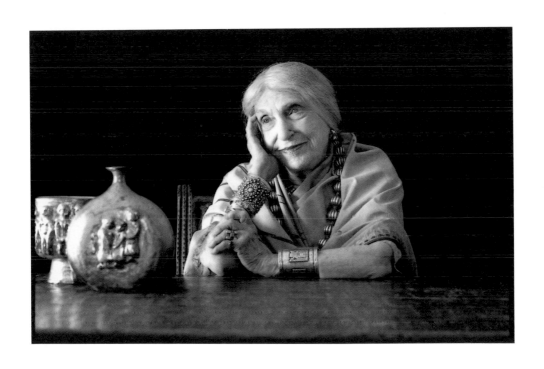

Everybody wants freedom. We resent rules imposed from the outside, which can create chaos for the individual. But self-discipline is vital. We get nowhere without it.

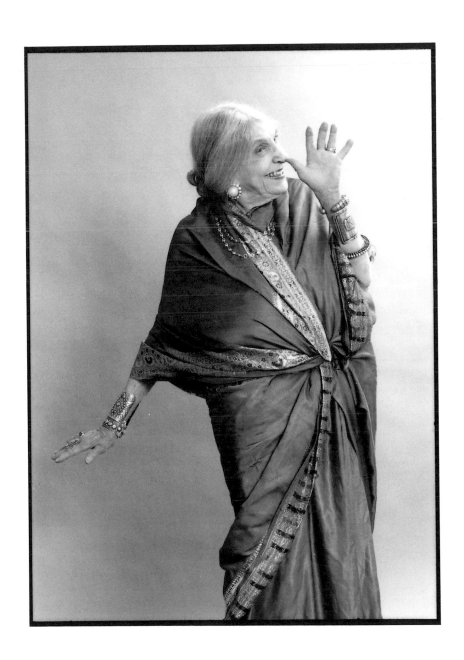

We develop through experience. Therefore, hardships and misfortunes challenge us. It is in overcoming mistakes that we touch the song of life.

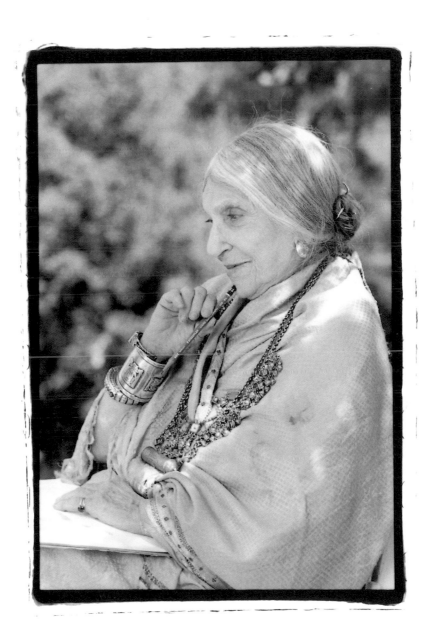

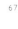

A scientist once said there is no such thing as time. So perhaps we do not exist in time as we know it. We cannot hold on to the past or grab onto the future, and the present is ever gone.

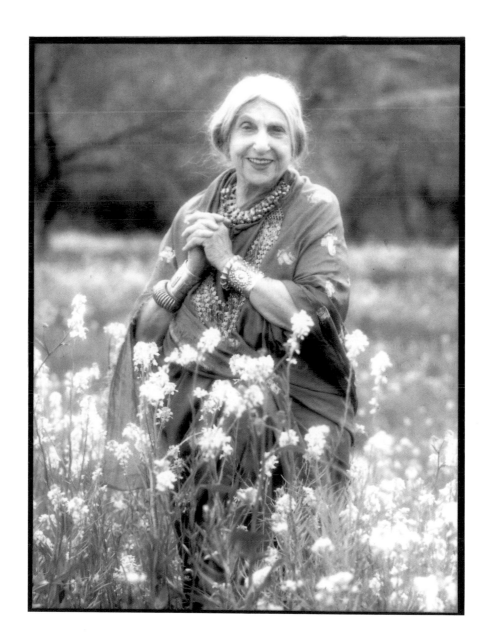

There are three things important in life:
honesty, which means living free of the
cunning of the mind; compassion, because
if we have no concern for others, we are
monsters; and curiosity, for if the mind is
not searching, it is dull and unresponsive.

ACKNOWLEDGMENTS

I would like to acknowledge the following people for their kind assistance and advice:
Stephanie Dragovich, David Van Gilder, and Noureddine El-Warari, master printer.

PHOTOGRAPHS
(by page number)